Hace diecisiete años
que trabajo
en un proyecto.

Siempre mal.

He fundido la arcilla
el hierro
las piedras
las botellas
la sal y la arena

He quemado la tierra
erosionado las jarras
metido yeso en el horno
modelado con bolsas de plástico

Roto a pesar mío
aún ayer
una y otra pieza

Cada una me lleva
hasta la siguiente

Me acuerdo de pocas

Escasas ideas

Escasas palabras

Quizás
no sea ningún
proyecto
ni haga diecisiete años

Quizás
sea un rastro
un sendero
ladeando en círculos
antiguas labranzas.

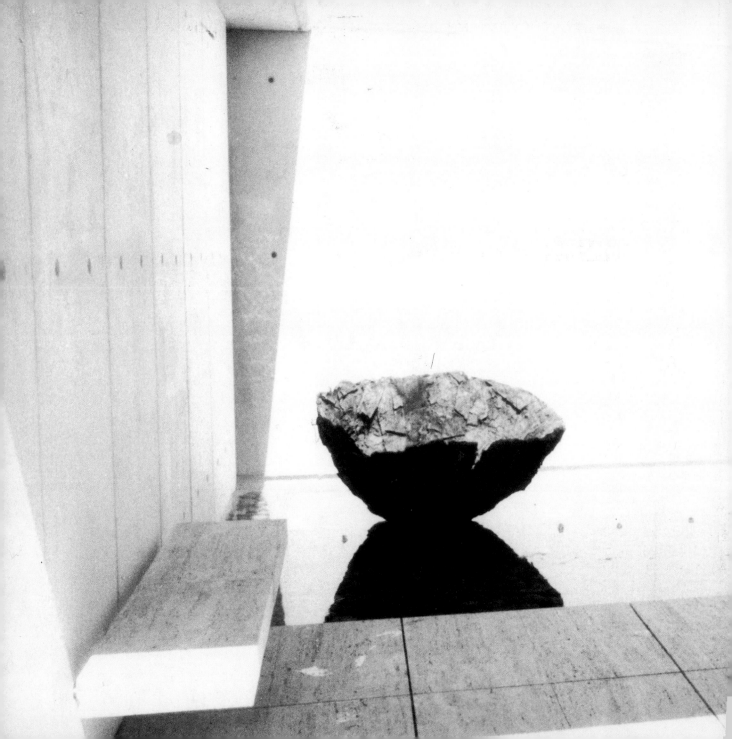

Claudi
Casanovas

Published 1996 in association with Galerie Besson, London
by Marston House, Marston Magna, Yeovil, Somerset BA22 8DH

ISBN 1 899296 02 6

British Library Cataloguing-in-Publication Data.
A catalogue record for this book is available from the British Library.

Photographs by Hisao Susuki, Michael Harvey, François Goalec and Cece.

Illustration on title page: Obi la Callada ('Obi the silent') *c. 100 cm diam.*
Collection Xavier Vives, Igualada, Spain.

German translations by Roland Held

Typeset by Kendalls, Milborne Port, Sherborne, Dorset
Printed by Remous Ltd, Milborne Port, Sherborne, Dorset
Bound by Bookcraft, Midsomer Norton, Somerset

Claudi Casanovas

'Everything Casanovas does is an adventure,' says Claude Champy, the French potter, using the French word *aventure*, which implies a serious grappling with the unknown. He recognizes in Casanovas a determined experimentor, innovative, creative and unafraid. This young Catalan, still on the upward curve of his career, could change the European concept of ceramic art more than anyone since Bernard Leach half a century ago. Like Leach, he has breathed in the tradition-laden air of Japanese ceramics, but instead of trying to find a fusion of East and West, he has concentrated on elementals, and adapts a Bizen aesthetic to a more mechanised and architectural context.

His work is big and muscular – individual works stand as high as a man and can weigh 300 kg – and as all sculptors know, the bigger the work the more difficult and intense the creative effort. Just to enlarge an idea is not enough; it has to be a big enough idea in the first place to fill the volume or the wall, and as Casanovas' work gains in size it also gains in its aesthetic weight. .

Forty years old at the time of writing, Casanovas has spent all his life in Catalonia. Born in Barcelona in 1956, his family moved inland to Olot in the centre of the volcanic basin of the Garrotxa, where his father was working in the textile industry. He went back to Barcelona at the age of 18 to study theatre and ceramics and two years later he was working there in an *atelier céramique,* specializing in stoneware. Using the wheel, Claudi produced domestic pottery, and moved back to Olot in 1978 with a colleague to found a

potters' cooperative. In that year he won the first prize in the National Ceramics Concurso in Manises, near Valencia. His cooperative continued to work and exhibit into the late 1980s, by which time Casanovas' sculptural ceramics had taken over from domestic pottery and his involvement in the cooperative was phased out.

He had exhibited work in Germany in 1981, and the first of many Casanovas one-man shows was held at the Museu Comarcal in Olot in 1982, followed by one-man shows in several Spanish cities. In 1985 and 1986 he gained international prizes in Italy (Emilia Romagna Prize, Faenza) and France (Grand Prix de la Ville de Vallauris) and in 1986 his work was first shown in London, Tokyo and Paris. The succeeding decade has seen Casanovas' work exhibited worldwide and increasing in scale and daring.

Thanks to the generosity of his family, he has been able to pursue, alone in his studio overlooking the valley of the Riudaura, a continuous series of experiments with clay. '*There is an engineering solution to every problem,*' he states, and inverts the Hans Coper maxim of 'why before how' with the conviction that if something needs doing, even if it has never been done before, he will find a way. Incorporating organic material – straw, dung, rice, maize stalks, flour – as well as metals and metal oxides, into clay, creating negative forms with the bonus of a reduction aureole around the spaces of combustion, and then using sand-blasting techniques to erode the fired surface, there are no boundaries to Casanovas' ceramic *aventures.* He employs machinery, not assistants, to help him with

heavy weights, and two massive desolate skips stand near his studio to collect the remains of objects blown apart or below expectations.

Casanovas is not a teacher, but in his demonstrations, because he tackles old questions in new or inverted ways, he always has a dramatic effect on his audience: he can change the stance of other potters to their art. Once, at the *Printemps des Potiers* in Bandol, he chose to demonstrate for French potters the effect of liquid nitrogen – at –300°C – when poured into crucibles of moist clay, to show the appearance of instantaneous freezing of the inner layers, revealed as a shell when the outside is pulled off. The results in themselves were not significant but, just as running a video backwards gives some insights into human movements and gestures, so speeding up or reversing familiar ceramic sequences can give a better understanding of the natural processes in clay and their aesthetic implications.

It is the clay itself, not the vitreous coats that centuries of ceramic experts have sought to perfect, which is Casanovas' obsession, and researches into its behaviour in combination with other materials give him an agenda which, he feels, is enough to fill a lifetime. From the point of view of an industrial chemist or physicist such a random agenda, with aesthetic rather than utilitarian criteria, would be confused and pointless, but of course this is exactly the strength of his position – by taking haphazard but well controlled forays into scientific experimentation, he arrives at a wide-screen understanding of how clayey materials perform and what secrets they can reveal.

Rain, wind, intense heat, intense cold, erosion, deposition – all the active factors in physical geology – produce infinitely varied land forms which are fascinating for both child and scientist. Casanovas is at pains to indicate that he has no special interest in geology, and that any resemblance between his fired work and rocks and land forms is coincidental. But he knows that he is starting with the *end* product of geological processes, and using similar forces to create a physical response in these aluminosilicates.

Here is a key to his ceramic philosophy or quest: that the potter's materials start in a chaotic state and end, when shaped and decorated, in stability and permanence. His aim is to work somewhere in the middle of this sequence by creating work which is permanent yet essentially unfinished, and by carving before firing and sand-blasting afterwards he has both the attitude and techniques of a sculptor. Yet his mentor is an archetypal potter, Ryoji Koie, whom he visited in Japan in 1990, and in whose studio he worked for two months preceding his 1991 exhibition at the Koyanagi gallery in Tokyo. Koie is the only ceramic artist seriously to have influenced Casanovas, but by his attitude to ceramics as much as by is work. Casanovas learned from Koie to avoid a personal ceramic style, for with a dominating style you arrive at repetition, and he learned that ceramic style is different from a ceramic voice. He claims that he was thrown off balance by Koie, while learning to admire Koie's own equilibrium and his attitude to clay, which he describes as '*like that of a child playing with a toy*'.

Casanovas uses a personal mixture of local clay from the Garrotxa region with imported stoneware clay from France, and in the past has used the grey-firing clay of La Borne and porcelain bodies. But of course it is the combustible materials added to the clay, burned away in reduction, and the subsequent sand-blasting which produces the eroded forms, for which he is best known.

In a short introduction it is not possible to describe in detail Casanovas' working methods, but from the first he has made use of non-ceramic materials for moulds and the internal cores of vessels. For instance, by tensioning a heavy square plastic sheet above a void, and pouring in plaster, he has made a gentle, mathematically perfect, smooth, shallow hump mould of prodigious size. By inflating thick heat-welded polythene 'cushions' and applying plaster to the surface, strengthened with substances such as glassfibre, an equally perfect hollow mould can be made, in which the lentil-like disc forms, some of which are shown in this book, can be started.

On returning from Japan he experimented in Olot,

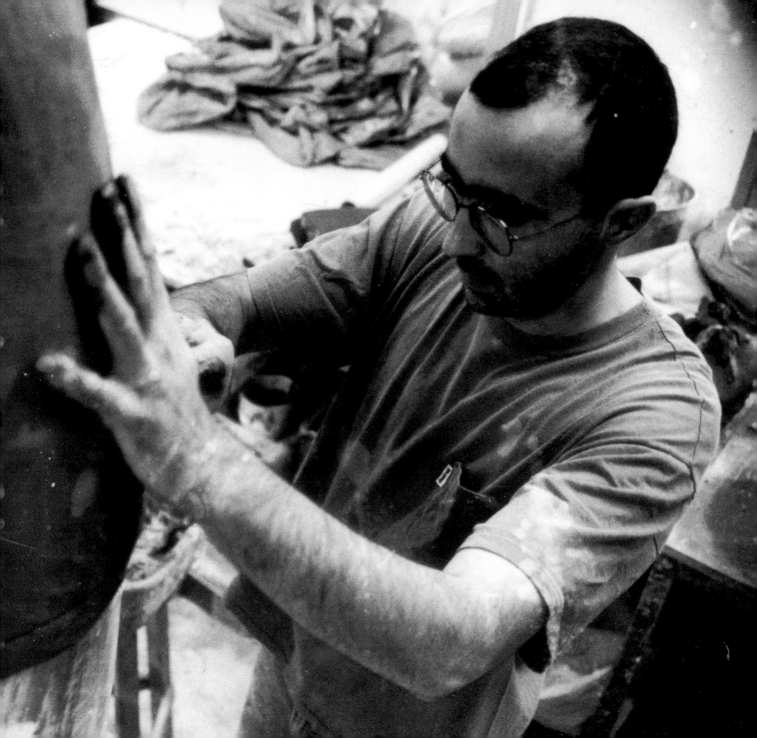

using a two-chamber kiln, with a 'glazing' process more at home in a metal foundry. He melted lumps of volcanic magma from hills near his home in a crucible in the high-temperature second chamber, then removed the crucible with tongs and poured the contents into fired stoneware bowls heated to 1100°C in the first chamber, making thickly 'glazed' yunomi.

In 1993 he made a series of about forty massive jars by a complicated technique which allowed the vertical striations clearly shown in Plates 8 and 9 to be a practical reality. For these jars the process starts with the making of a mould over an inflated heat-welded plastic bag form. A second identical mould placed face to face with the first makes a two-piece plaster mould familiar to potters in ceramics factories, though on a much larger scale than would be practical in industry, for the space enclosed is 140 cm high. Instead of making a clay cast, he made a thin PVC resin cast which he then filled to solid with a polystyrene core, resembling a torpedo or giant suppository. Clay first enters the project at this stage, for long narrow strips of laminated coloured clay, covered in cellulose film and rolled up like a Swiss roll, are unrolled vertically onto an engobe overlying the solid polystyrene core from which the PVC skin has been removed. Thus a ceramic vessel as sound as a conventionally coiled pot is built up around a core, but with the unconventional directional structure visible and enhanced by rouletting or the firing of combustible material in the clay. The now prodigious weight of these huge unfired vessels necessitated a gyroscopic device to turn them from horizontal to upright without distortion, and then – a typical Casanovas improvisation – the dissolving to liquid of the polystyrene core which is run out through a small hole near the base of the form, to allow the clay vessel to dry without cracking. The variety of colour, texture and surface is revealed after firing. These jars composed a finite series, and the artist moved on to new concepts.

In his vast studio lie the witnesses to past and current experiments, huge carapaces or skeletons made of plaster, steel, resin. A most recent series of weighty sculptural crucibles began with the form illustrated in the frontispiece, photographed in its position in the house of Xavier Vives in Igualada. Part casting, part carving, some of these double-skinned vessels are sprayed with oxides between two firings and were first exhibited in Châteauroux in 1995. An extended series of fifteen more giant forms was prepared for exhibition at the Hetjens Museum in Düsseldorf in September 1966, and at the same time Casanovas returned to the wheel for the first time in fifteen years to make a series of tea bowls for Galerie Besson in London.

There is so much to see in a work by Casanovas that potters can be forgiven for enquiring into the 'how?' without asking the 'why?' If questioned, however, the artist will make it clear that the complexity of his method is a means leading towards greater refinement and simplicity – his material summed up in a single form, a single clay and a single colour. Artists like Brancusi and Hans Coper are touchstones in the pursuit of ever simpler, denser form, and Casanovas intends to tread the same path. In his research into the characteristics and the essence of clay, he sees himself as working like a surgeon, dissecting, or a biologist with a microscope, teasing his material apart, through its structures and patterns, to a vestigial form, and finally to the elements themselves.

Tony Birks
August 1996

Claudi Casanovas

"Alles, was Casanovas macht, ist ein Abenteuer", sagt der französische Töpfer Claude Champy, und er gebraucht dabei das Wort *aventure*, das ein ernsthaftes Ringen mit dem Unbekannten beinhaltet. In Casanovas erkennt er einen entschlossenen Experimentator, neugierig auf Neues, schaffensfreudig und unerschrocken. Der junge Katalane, der noch in der Aufwärtskurve seiner Laufbahn steht, könnte die europäische Sicht auf die Kunst der Keramik stärker verändern als irgendjemand seit Bernard Leach vor einem halben Jahrhundert. Wie Leach hat er die traditionsgesättigte Luft japanischer Keramik eingesogen, doch anstatt eine Verschmelzung von Ost und West herbeiführen zu wollen, hat er sich auf die Grundtatsachen besonnen; er wendet eine Bizen-beeinflußte Ästhetik an in einem stärker mechanisierten und architektonischen Umfeld.

Sein Schaffen ist mächtig und spannkräftig – Einzelwerke können mannshoch sein und 300 kg wiegen-, und wie alle Bildhauer wissen: je größer das Werk, desto schwieriger und intensiver der schöpferische Einsatz. Eine Idee nur "aufzublasen" genügt ihm nicht; sie muß von vornherein groß genug sein, um ein Volumen oder eine Wand zu füllen, und in dem Maße, wie Casanovas' Werk an Abmessungen anschwillt, gewinnt es auch an ästhetischem Gewicht.

Zum jetzigen Zeitpunkt vierzig Jahre alt, hat Casanovas sein ganzes Leben in Katalonien verbracht. Nachdem er 1956 in Barcelona geboren wurde, zog seine Familie nach Olot ins Landesinnere um, ins Herz des Vulkanbeckens des Garrotxa, wo sein Vater in der Textilindustrie beschäftigt war. Im Alter von 18 ging er nach Barcelona zurück, um das Theaterhandwerk und die Töpferei zu erlernen; zwei Jahre später arbeitete er dort in einem *atelier céramique*, wo er sich auf Steinzeug spezialisierte. An der Töpferscheibe produzierte er Gebrauchsgeschirr; zusammen mit einem Kollegen kehrte er 1978 nach Olot zurück, um eine Töpferkooperative zu gründen. Im selben Jahr gewann er den Ersten Preis im Nationalwettbewerb für Keramik in Manises bei Valencia. Seine Kooperative führte ihre Produktions- und Ausstellungstätigkeit bis in die späten 8oer Jahre fort; damals aber hatte Casanovas' skulpturale Keramik das Gebrauchsgeschirr abgelöst, und seine Beteiligung an der Kooperative klang allmählich aus.

Bereits 1981 hatte er Arbeiten in Deutschland ausgestellt; 1982 fand Casanovas' erste Einzelschau im Museu Comarcal in Olot statt, gefolgt von weiteren Einzelpräsentationen in mehreren Städten Spaniens. 1985 und 1986 gewann er internationale Preise in Italien (Emilia-Romagna-Preis, Faenza) und Frankreich (Großer Preis der Stadt Vallauris), und 1986 wurde sein Schaffen erstmals auch in London, Tokio und Paris gezeigt. Im darauffolgenden Jahrzehnt reisten seine Arbeiten, die währenddessen an Dimension und Kühnheit noch zunahmen, um die ganze Welt.

Dank der Großzügigkeit seiner Familie sah er sich in der Lage, in seinem einsamen Atelier, von dem aus er das Tal des Riudaura überblickt, eine fortlaufende Serie von Versuchen mit Ton durchzuführen. "Es gibt für jedes Problem eine technische Lösung", sagt er und kehrt dabei Hans Copers Maxime des "Warum-vor-Wie" um, überzeugt, daß er einen Ausweg findet, wenn

etwas unbedingt getan werden muß – selbst wenn es nie zuvor probiert worden ist. Das Untermischen von organischem Material – Stroh, Dung, Reis, Maiskolben, Mehl – wie auch von Metallen und Metalloxiden in den Ton, was Negativformen hinterläßt mit dem besonderen Reiz einer Reduktionsaura um die ausgebrannten Hohlräume, und schließlich der Gebrauch des Sandstrahlverfahrens zum Abschleifen der gebrannten Oberfläche – das zeigt schon, daß Casanovas' keramische *aventures* keine Grenzen dulden. Er setzt Geräte ein statt Assistenten, die ihn im Umgang mit den schweren Gewichten unterstützen, und zwei massive, trostlose Lastcontainer warten in der Nähe seines Ateliers, um aufzusammeln, was übrigbleibt von den zersprungenen Stücken oder denen, die hinter den Erwartungen zurückblieben.

Casanovas ist kein Lehrer, aber in seinen Arbeitsvorführungen beeindruckt er sein Publikum trotzdem zutiefst, weil er alte Probleme neu oder verquer anpackt; er bringt es sogar fertig, die Sichtweise anderer Töpfer auf ihr Metier zu ändern. Beim *Printemps des Potiers* in Bandol erlaubte er es sich einmal, vor französischen Kollegen die Wirkung von flüssigem Stickstoff (bei ca. −300°C) zu demonstrieren, wenn man ihn in Tiegel von feuchtem Ton gießt, um das Eintreten eines sofortigen Gefrierens der inneren Schichten zu beweisen – was wie eine Austernschale wirkt, wenn die äußere Schicht weggeschält wird. Die Resultate an sich waren nicht sonderlich bemerkenswert, doch genau wie ein rückwärts gespieltes Video uns Aufschlüsse gibt über menschliche Bewegungen und Gesten, so vermitteln uns vertraute keramische Vorgänge im Zeitraffer oder Rückwärtslauf ein besseres Verständnis der Tonmasse, was ihre natürlichen Prozesse und ästhetischen Effekte betrifft.

Es ist der Ton selber, nicht der verglaste Mantel, an dessen Perfektion die Töpfereiexperten sich seit Jahrhunderten abmühen, dem Casanovas' Besessenheit gilt, und sein Verhalten in Kombination mit anderen Materialien zu erforschen gibt ihm ein Programm vor, das ihn, wie er fühlt, bis ans Lebensende beschäftigen

wird. Aus dem Blickwinkel eines Industriechemikers oder-physikers wäre ein derart willkürliches Programm mit seinen auf Schönheit eher als Nützlichkeit ausgerichteten Kriterien gewiß wirr und sinnlos, aber genau darin liegt die Stärke seiner Position – indem er aufs Geratewohl und dennoch streng kontrolliert Vorstöße ins wissenschaftliche Experimentieren unternimmt, gelangt er zu einem weitgespannten Verständnis dessen, wie tonartige Stoffe sich verhalten und welche Geheimnisse sie zu offenbaren vermögen.

Regen, Wind, intensive Hitze oder Kälte, Erosion, Ablagerung – die aktiven Faktoren der Geologie des Terrains – bringen unendlich abwechslungsreiche Landgestaltungen hervor, die für ein Kind ebenso faszinierend sind wie für den Wissenschaftler. Casanovas scheut keine Mühe, zu versichern, daß er kein Spezialinteresse an Geologie hegt und daß jede Ähnlichkeit zwischen seinen gebrannten Scherben und Felsen bzw. Landformationen rein zufällig ist. Doch ist er sich darüber im Klaren, daß er mit dem Endprodukt eines geologischen Prozesses beginnt und analoge Kräfte zur Anwendung bringt, um eine physikalische Reaktion in den Aluminiumsilikaten hervorzurufen. Hier wäre denn ein Schlüssel zur Philosophie bzw. zum Bestreben dieses Keramikers: daß die Töpferrohstoffe anfangs noch in einem chaotischen Zustand sind, um, zeigen sie erst Form und Dekor, bei Stabilität und Dauerhaftigkeit anzulangen. Sein Ziel ist es, irgendwo in der Mitte dieser Abfolge zu arbeiten und Ergebnisse hervorzubringen, die dauerhaft und doch im Grunde unvollendet sind; und indem er vor dem Brennen ans Schneiden und hinterher ans Sandstrahlen geht, zeigt er sowohl die Haltung wie auch die Techniken eines Bildhauers. Dennoch ist sein Mentor ein urtypischer Töpfer: Ryoji Koie, den er 1990 in Japan aufsuchte und in dessen Werkstatt er zwei Monate vor seiner 1991er Ausstellung in der Koyanagi-Galerie in Tokio tätig war. Koie ist der einzige Keramiker, der Casanovas ernstlich beeinflußt hat, und zwar mit seiner Auffassung von Keramik ebenso wie mit seinem Oeuvre. Von Koie lernte Casanovas, einen persönlichen keramischen Stil zu vermeiden, weil man

mit einem hervorstechenden Stil irgendwann in Wiederholung verfällt, und er begriff auch, daß keramischer Stil nicht dasselbe ist wie keramischer Ausdruck. Er behauptet, daß Koie ihn einfach ins Schleudern gebracht hat, während er dabei war, Koies eigenen Gleichmut schätzen zu lernen und seine Einstellung zum Ton, die er vergleicht mit "der eines Kindes, das im Spielen vertieft ist".

Casanovas benutzt eine spezielle Mischung von Ton, der aus der Garrotxa-Region stammt, und importiertem Steinzeugton aus Frankreich; früher hat er auch schon mal zum graubrennenden Ton von La Borne und zu porzellaniger Substanz gegriffen. Natürlich aber sind es die entflammbaren Materialien, die dem Ton beigemengt werden und bei der Reduktion verbrennen, sowie das anschließende Sandstrahlverfahren, was die zerklüfteten Formen zuwegebringt, für die er am berühmtesten ist.

In einer kurzen Einführung ist es unmöglich, Casanovas' Arbeitsweisen eingehender zu beschreiben, doch von Anfang an hat er Gebrauch gemacht von nicht-keramischen Materialien für die Formen und Innenkerne seiner Gefäße. Zum Beispiel erzielte er, als er eine schwere viereckige Plastikbahn über einem Hohlraum verspannte und Gips eingoß, eine sanfte, glatte, flache, mathematisch perfekte Buckelform von verblüffender Größe. Durch Aufpumpen dicker wärmever schweißter Plastikkissen, über deren Oberfläche man Gips streicht, verstärkt mit Stoffen wie Glasfaser, läßt sich eine nicht minder perfekte Hohlform zubereiten, in der die linsenartigen Scheibenkörper, von denen einige in diesem Katalog abgebildet sind, in Angriff genommen werden können.

Nach seiner Rückkehr aus Japan experimentierte er in Olot, wo er einen Zweikammer-Brennofen benutzte, mit einem Glasurprozeß, den man eigentlich eher in einer Metallgießerei vermuten würde. Er schmolz Klumpen vulkanischen Magmas aus den Hügeln hinter seinem Haus in einem Schmelztiegel in der hochtemperierten zweiten Ofenkammer; dann nahm er den Tiegel mit einer Zange heraus, um den Inhalt in gebrannte Steinzeugschüsseln zu schütten, die er in der ersten Kammer auf 1100°C vorgeheizt hatte.

1993 stellte er eine Serie von ungefähr vierzig wuchtigen Krügen her mittels einer komplizierten Technik, der es zu verdanken ist, daß die Vertikalstreifen, zu sehen auf Tafel 8 und 9, machbar wurden. Für diese Krüge beginnt der Prozeß mit der Anfertigung einer Form über einer aufgepumpten wärmeverschweißten Plastiktüte. Eine zweite, identische Form, der ersten genau angepaßt, ergibt eine zweiteilige Gipsform – Töpfern in Keramikfabriken wohlvertraut, obschon viel größer dimensioniert, als es in der Industrie praktikabel wäre, da der eingeschlossene Raum 140 cm hoch ist! Statt eines Tonabgusses machte Casanovas einen dünnen Abguß von Kunstharz, den er sodann kompakt auffüllte mit einem Styroporkern, was einem Torpedo oder gigantischen Zäpfchen ähnlich sah. Erst in diesem Stadium tritt der Ton hinzu; lange schmale Streifen farbig geschichteten Tons, folienüberzogen und zusammengerollt wie eine Biskuitrolle, werden senkrecht abgezogen auf eine Engobe, die an dem kompakten Styroporkern aufgebracht ist, von dem die Kunstharzschicht zuvor entfernt wurde. So läßt sich ein keramisches Gefäß, so solide wie ein herkömmlich aus Tonwülsten gefertigter Topf, um einen Kern herum aufbauen, wobei jedoch die ungewöhnliche Richtungsstruktur sichtbar bleibt und noch unterstrichen wird durch Roulettieren bzw. das Sichverflüchtigen des entflammbaren Materials im Ton. Das mittlerweile ungeheure Gewicht dieser riesigen Gefäße vor dem Brand erforderte eine Drehvorrichtung, um sie ohne Verformung aus der Horizontalen in die Vertikale bringen zu können; ebenso nötig war – eine für Casanovas typische Improvisation – die Umwandlung des Styroporkerns in Flüssigkeit, die man durch ein kleines Loch in Bodennähe ablaufen ließ, um es dem Tongefäß zu erlauben, ohne Rißbildung auszutrocknen. Die Vielfalt von Farbe, Textur und Oberfläche wird erst nach dem Brand offenbar. Die besagten Krüge verkörperten eine abgeschlossene Serie, nach welcher der Künstler zu neuen Konzepten voranschritt.

In seinem geräumigen Atelier ruhen die Zeugen vergangener und gegenwärtiger Experimente, riesige Panzer oder Skelette aus Gips, Stahl, Harz. Eine vor kurzem entstandene Serie gewichtiger skulpturaler Tiegel nahm ihren Auftakt mit dem Stück, das auf dem Frontispiz wiedergegeben ist, fotografiert an seinem Platz im Haus von Xavier Vives in Igualada. Zum einen Teil Guß, zum anderen Skulptur, sind einige dieser doppelwandigen Gefäße zwischen zwei Brennvorgängen mit Oxiden besprüht. In Châteauroux waren sie 1995 erstmals ausgestellt. Eine umfangreiche Serie von weiteren fünfzehn Riesenstücken wurde für die Ausstellung im Düsseldorfer Hetjens-Museum im September 1996 vorbereitet; um die gleiche Zeit setzte sich Casanovas zum ersten Mal seit fünfzehn Jahren wieder an die Töpferscheibe, um für die Galerie Besson in London eine Reihe Teeschalen zu drehen.

Es gibt in jeder Arbeit von Casanovas so viel zu entdecken, daß es verzeihlich ist, wenn Töpfer nur dem "Wie" nachspüren, ohne sich auch nach dem "Warum" zu erkundigen. Wenn man jedoch ihn befragt, wird der Künstler klarstellen, daß die Komplexität seiner Schaffensweise ein Mittel ist, das ihn zu größerer Läuterung und Schlichtheit führen soll – sein Material, zusammengefaßt in einer einzigen Form, einer einzigen Sorte Ton, einer einzigen Farbe. Künstler wie Brancusi und Hans Coper sind Wegweiser beim Streben nach einer immer einfacheren, konzentrierteren Form, und Casanovas hat vor, den gleichen Weg zu gehen. In seiner fortdauernden Erforschung der Eigenschaften und des Wesens von Ton sieht er sich am Werk wie einen Chirurgen, der eine Sezierung vornimmt, oder einen Biologen mit dem Mikroskop, der sein Material behutsam zerlegt, sich voranarbeitet durch Strukturen und Muster, bis hin zur Rudimentärform und schließlich zu den Elementen.

Tony Birks
August 1996

1 Three amphorae 1985
Sandblasted stoneware, c.120 cm high

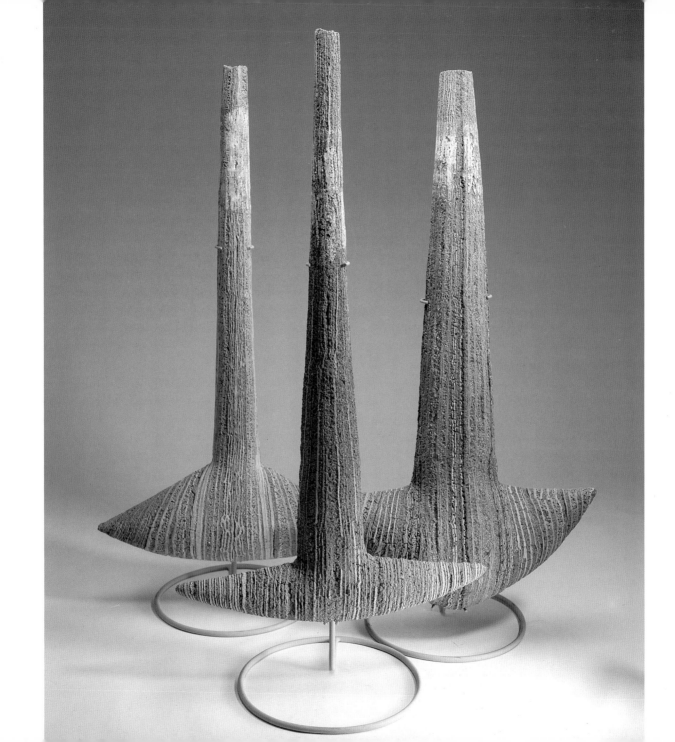

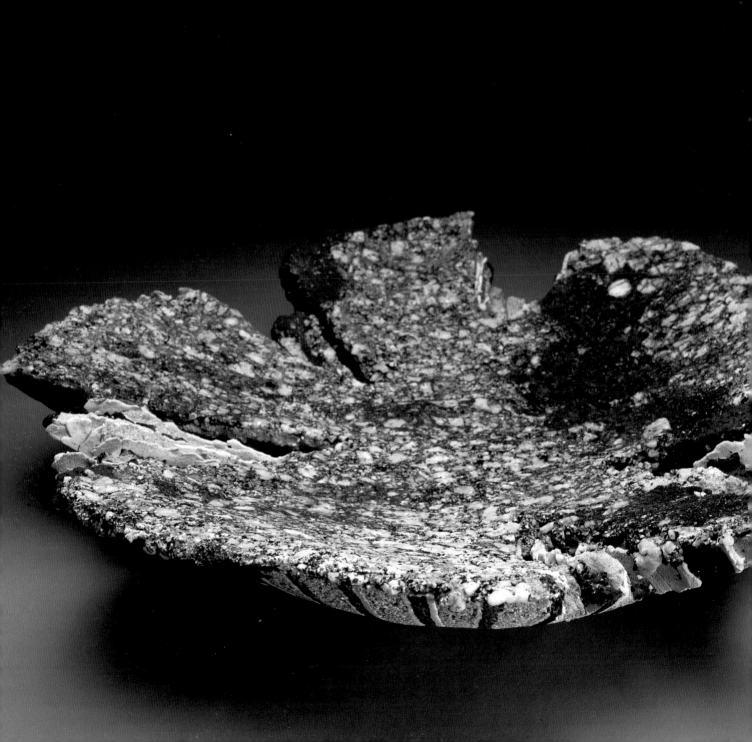

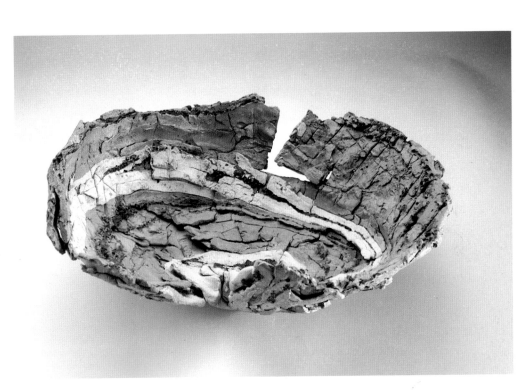

3 Split bowl 1987
Stoneware, mixed clays, including clay from
Moutiers-en-Puisaye, c.50 cm diam.

2 *(left)* Split plate 1986 *Stoneware and melted granite, c.70 cm diam.*

There comes a moment when I have nothing left but the certainty of what I do not want. I try to deceive myself, I search for a major answer, an ideal stroke: I put all my faith in anything, like a shipwrecked man in an improvised raft, like a frightened animal for which any little path is a way out. And one after another I start to break up weeks of work, dried pieces and fired alike. I say to myself, 'You're at the beginning, this has already happened to you many times before, you can manage.' And I carry on breaking them, scared as I am. I have nothing left but the certainty of what I do not want.

Es kommt der Augenblick, an dem mir nichts mehr geblieben ist als die Sicherheit dessen, was ich nicht will. Ich versuche mir etwas einzureden, ich suche nach der Antwort, nach dem Gedankenblitz, ich lege meinen ganzen Glauben in dies oder jenes, wie ein Schiffbrüchiger auf einem eilig zurechtgezimmerten Floß, wie ein verängstigtes Tier, dem der schmalste Pfad ein Ausweg scheint. Und nach und nach beginne ich, Wochen der Arbeit entzweizuschlagen, getrocknete wie gebrannte Stücke. Ich sage mir, "Du stehst doch am Anfang, es ist dir schon oft so ergangen, du kannst es noch schaffen." Und ich schlage sie weiter entzwei, sei's auch voller Angst.
 Nichts ist mir geblieben als die Sicherheit dessen, was ich nicht will.

4 Four large bowls 1988 *Stoneware, mixed clays, including clay from Moutiers-en-Puisaye. a: 100 cm diam. b: 60 cm diam. c: 79 cm diam. d: 80 cm diam.*

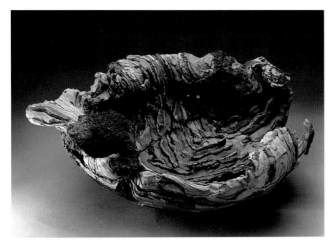

a

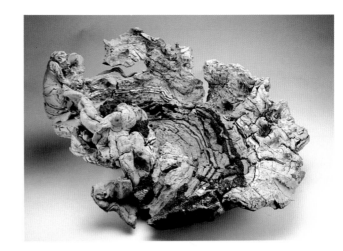

b

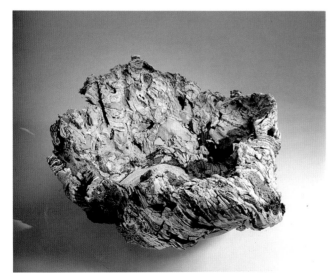

c

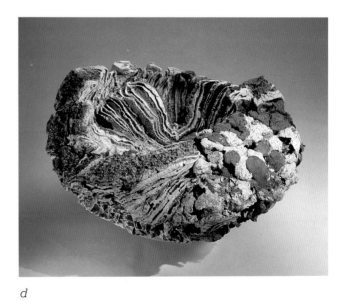

d

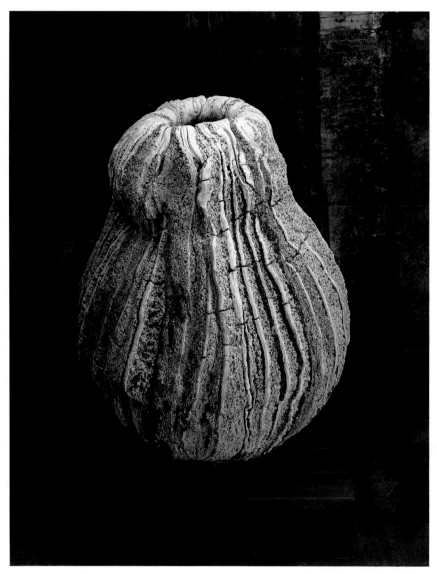

5 Jar 1990 *Stoneware, mixed clays, 70 cm high. Galeria Caramany, Girona*

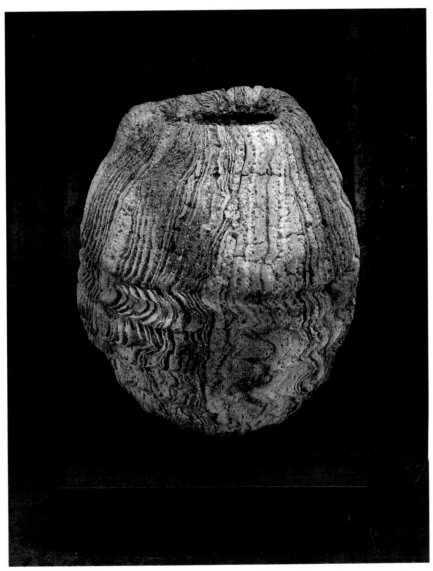

6 Jar 1990 *Stoneware, mixed clays, 82 cm high. Galeria Caramany, Girona*

I saw someone working at the potter's wheel and I found it magical. After the potter's wheel I tried many methods: biscuit and plaster casts, fused plastic casts, polyester resin, polyurethane cores, sandjet abrasive spraying of fired pieces, laying coatings of clay upon clay, inducing and simulating cracks . . . and all of these methods obey the primitive instruction first discovered at the wheel: the piece must not be touched; it must be left to grow from inside, as if it were being made by itself, and as if magic were possible.

Each tool offers several different possibilities which determine the outcome. The wheel captures water, agility, movement and coolness, but it is also the tool of memories. No other tool has made such a long journey from the past, accompanying so many generations. A piece created on the wheel evokes and extends roots into the past. Together with the indestructible character of fired clay it is like a storehouse full of history and human past. The wheel captures both the momentum of the present and the uncertainty of the past. I have forgotten the wheel but not the axis of its magic.

Ich schaute jemandem zu, wie er an der Töpferscheibe arbeitete, und ich fand einen Zauber darin. Nach der Töpferscheibe habe ich viele Methoden durchprobiert: Biskuit- und Gipsabgüsse, solche aus geschmolzenem Plastik, Polyesterharz, Polyurethan-Kerne, Sandstrahlbesprühen zum Scheuern gebrannter Stücke, das Übereinander vieler Tonschichten, das Herbeiführen und Simulieren von Rissen . . . und all diese Methoden gehorchen der simplen Einsicht, die ich zuerst an der Scheibe gewann: das Stück darf nicht berührt werden; man muß es von innen her wachsen lassen, als brächte es sich selber hervor, als wäre ein Zauber im Spiel.

Jedes Werkzeug bietet verschiedene Möglichkeiten, die das Ergebnis bestimmen. Die Scheibe kann Wasser, Bewegung, Behendigkeit, Kühle einfangen, aber sie ist auch das Werkzeug der Erinnerungen, sie ist voller Erinnerung. Kein anderes Werkzeug hat eine so lange Reise aus den Tiefen der Vergangenheit zurückgelegt, hat so viele Generationen begleitet. Ein Stück, das sich der Scheibe verdankt, beschwört und gewährt Wurzeln in die Vergangenheit. Im Bunde mit dem unzerstörbaren Charakter gebrannten Tons gleicht es einem Schatzhaus, randvoll mit Geschichte und menschlichen Leistungen. Die Töpferscheibe fängt sowohl die Wucht der Gegenwart ein als auch die Ungewißheit der Vergangenheit. Ich habe die Scheibe hinter mir gelassen, aber nicht ihre magische Achse.

7 Jar 1990 *Stoneware, mixed clays, 70 cm high. Galeria Caramany, Girona*

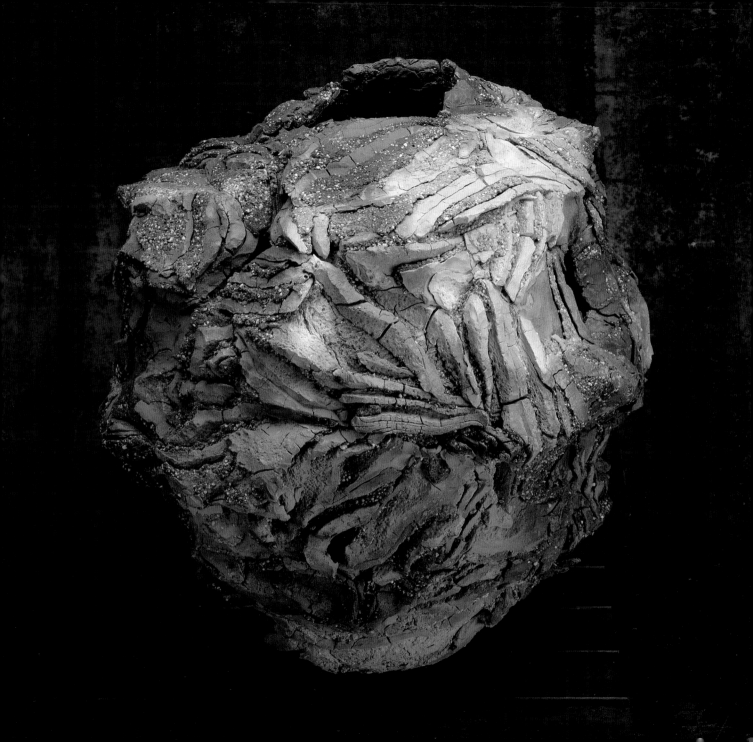

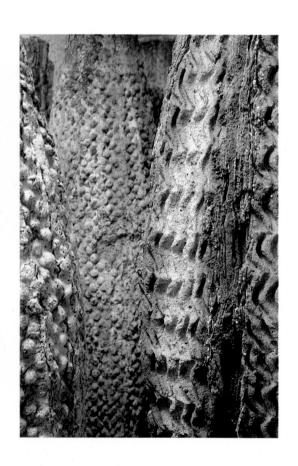

8 *Right* Group of tall jars, 1993 *Stoneware, mixed clays, 145 cm high. Exhibited Galeria Caramany, Girona, together with work by Ryoji Koie*

9 *Left* Detail

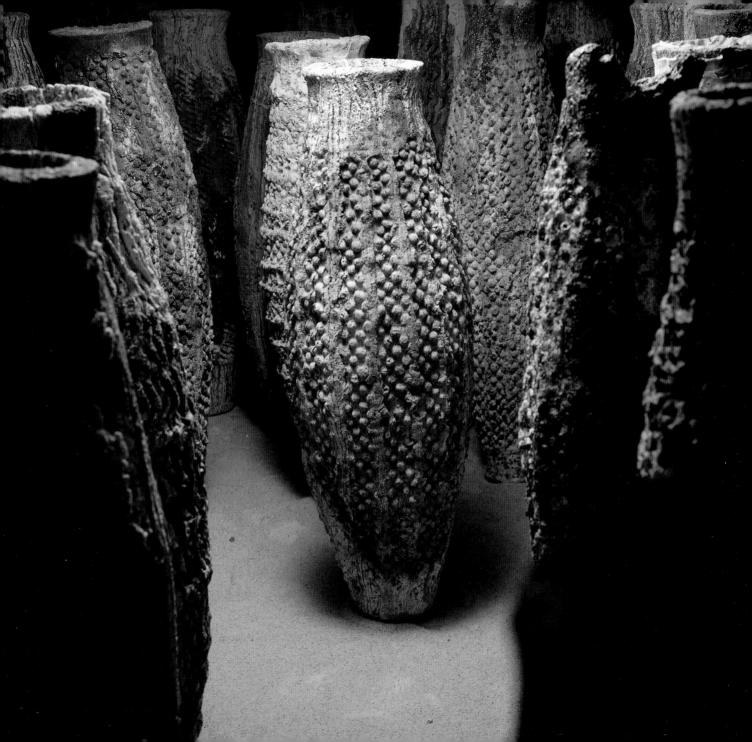

10 Long bowl 1991
 Stoneware, Tokoname clay, sandblasted, c.80 cm long.
 Exhibited Gallery Koyanagi, Tokyo

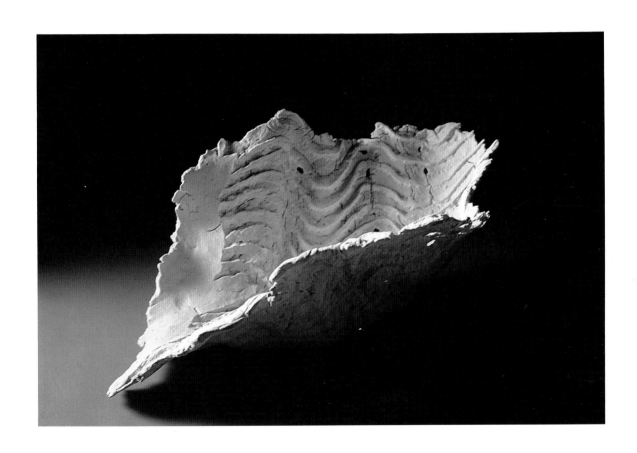

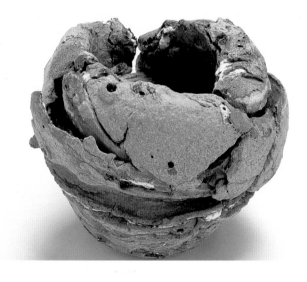

11 *Left* Teabowl 1996
Stoneware, thrown, mixed clays, 13 cm diam.
Exhibited Galerie Besson, London

12 *Right* Wall plate 1989
Stoneware with iron, 107 cm wide, 89 cm high
Galerie Besson, London

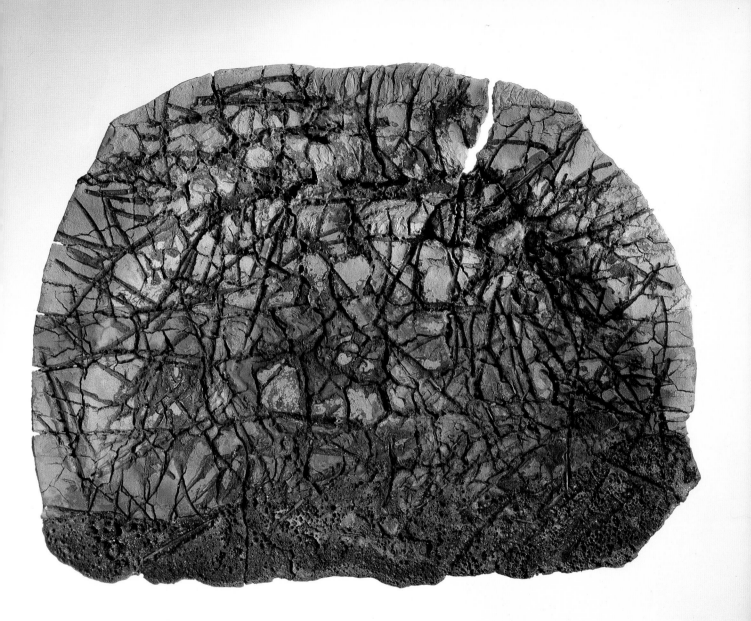

In Picasso's statement, 'I do not look for, I find,' the most revealing thing is the nearly arrogant tone of the statement. Does so much confidence, so much strength, not conceal many hours of doubt and quest? We cannot stop searching or 'having ideas'. Ideas or dreams make us what we are not, but we cannot stop ourselves from having them. Manolo Huguè, a contemporary of Picasso's, although less brilliant, used to say, 'I wanted to make a Venus and I'm getting a frog.' He made excellent frogs.

In Picassos Feststellung, "Ich suche nicht, ich finde", ist das Aufschlußreichste ihr fast arroganter Ton. Verbergen sich hinter so viel Selbstvertrauen, so viel Kraft, nicht zahllose Stunden des Zweifelns und Umhertastens? Wir können nicht aufhören damit, zu suchen oder "Einfälle" zu haben. Einfälle oder Träume machen uns zu dem, was wir nicht sind, und trotzdem hören wir einfach nicht auf, sie zu hegen. Manolo Huguè, ein Zeitgenosse Picassos, wenn auch nicht ganz so brillant, sagte immer, "Ich wollte eine Venus machen, und was dabei herauskommt, ist ein Frosch." Er machte ausgezeichnete Frösche.

13 Large wall plate 1991 *Stoneware, mixed clays with porcelain, 150 cm diam. Exhibited Galerie Besson London 1991, Town Hall Girona 1993, Garth Clark Gallery New York 1994. Private collection, New York*

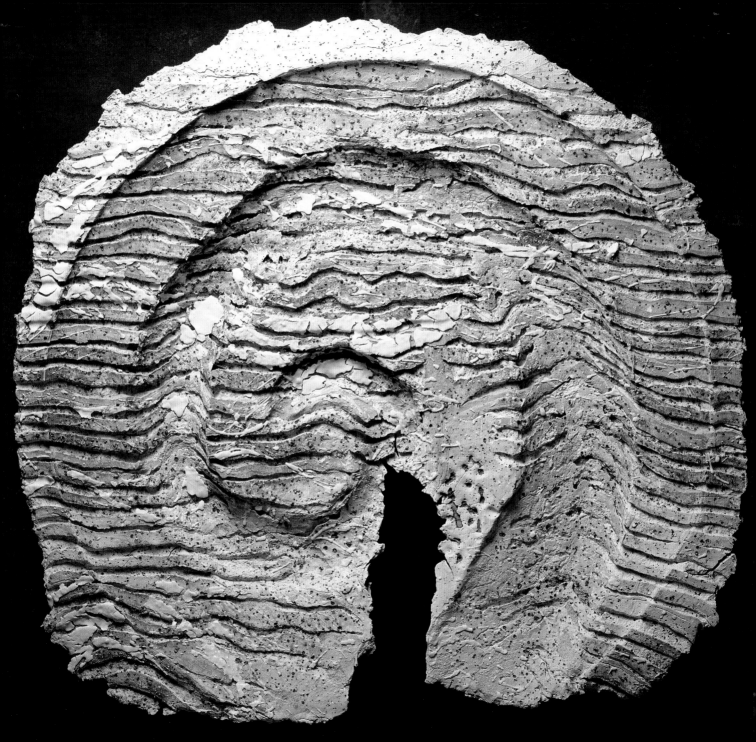

14 Two long bowls 1990 *Stoneware clay with feldspar; above: 34 cm wide,
110 cm long; below: 53 cm wide, 65 cm long*

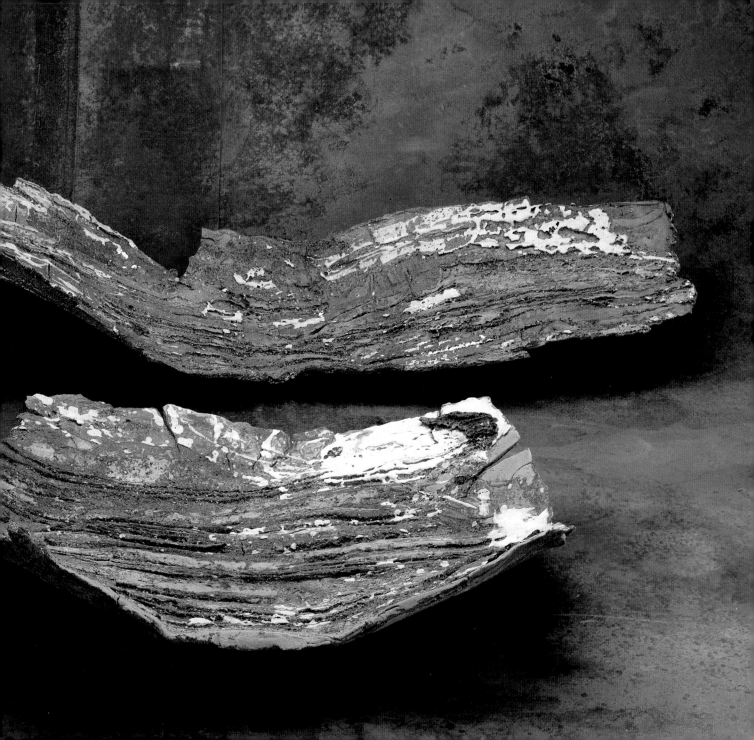

The first image is always remembered, it comes from the past.

I start pondering an old image seen at a glance, perhaps an earlier piece, perhaps several. I distance myself from precise memories. I try to be like a magnifying glass, an amplifier of lost details. From a single detail a whole world can unfold.

Thus the present becomes an excuse for condensing the past and extracting its essence.

An das erste Bild erinnert man sich immer; es kommt aus der Vergangenheit.

Für mich fängt es damit an, daß ich über ein altes Bild nachgrübele, das mir kurz durchs Auge gewandert ist, vielleicht ein Stück von früher, vielleicht mehrere. Ich halte Abstand von spezifischen Erinnerungen. Ich versuche, wie eine Lupe zu sein, wie etwas, das verlorene Details vergrößert. Aus einem einzigen Detail kann eine ganze Welt sich entfalten.

So wird die Gegenwart zum Vorwand, um die Vergangenheit zu verdichten und ihr das Wesen zu entlocken.

15 Large wall plate 1989 *Stoneware, mixed clays. c.150 cm diam. Collection of Sainsbury Centre for Visual Arts, Norwich*

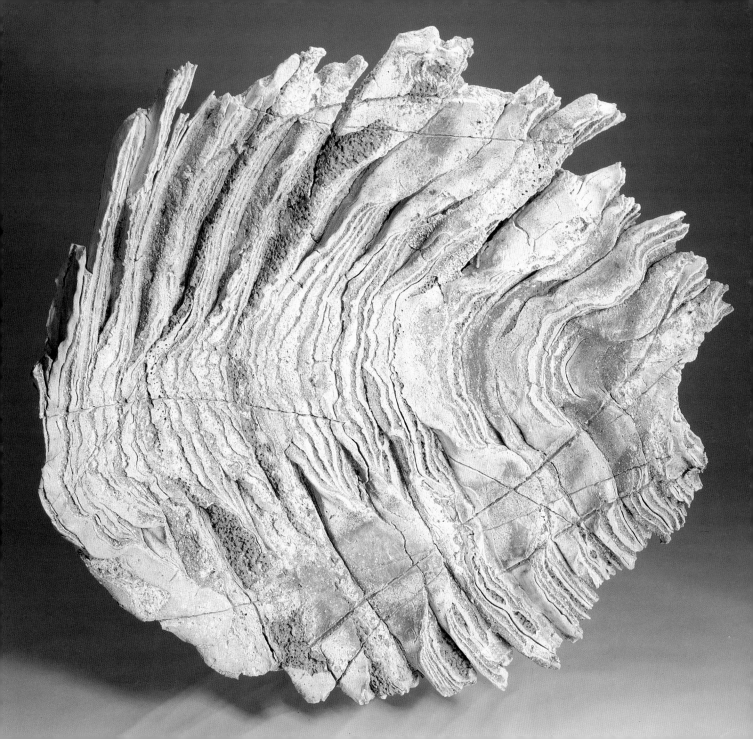

What is difficult about making ceramics is the fact that they are ceramics. They are not precious stones, or sculptor's stones; neither are they wood nor metal, nor plastic, nor drawings, not even big or small pieces of relief, and it is not easy to make them more, they are just ceramics.

Was am Herstellen von Keramiken so schwierig ist, ist der Umstand, daß sie keramischer Natur sind. Sie sind weder Edelsteine noch Bildhauerblöcke; ebensowenig wie sie Holz oder Metall sind oder auch Plastik, weder Zeichnungen noch größere oder kleinere Abschnitte eines Reliefs; es ist nicht leicht, aus ihnen mehr zu machen – es sind bloß Keramiken.

16 El dia de la Sega ('The day of the Harvest') 1992 *Stoneware, mixed clays, c.150 cm diam. Mino International Ceramic Competition, Tajimi, Japan, 1992. First prize winner (gold medal). Collection of Tajimi Town Hall*

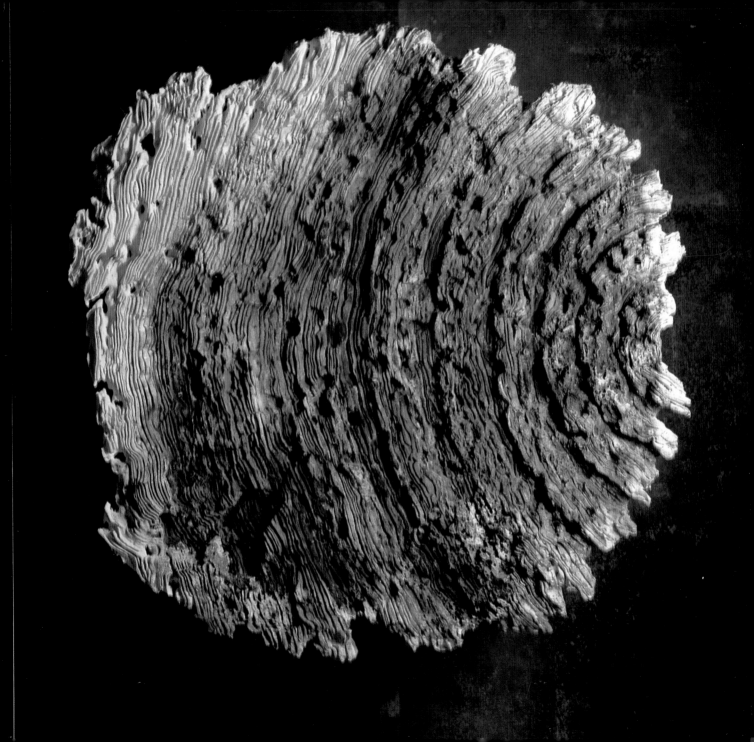

After some days of searching and of ideas emerging I take a step backwards. I break up all the work I have done and take a step back again; I resume a theme I have already put aside. 'You go and you return questioning, but it is only on the return that you see and understand, not on the outward journey.'

Nach mehreren Tagen des Suchens und Entwickelns einer Idee mache ich einen Schritt rückwärts. Ich zerbreche die ganze Arbeit, die ich bis dahin getan habe, und gehe noch einen Schritt zurück; ich greife ein Thema wieder auf, das ich schon zur Seite gelegt hatte. "Fragend ziehst du aus, fragend kehrst du zurück, aber erst bei der Rückkehr siehst und begreifst du, nicht beim Aufbruch in die Welt."

17 La nit de las Fogeres ('The night of the Bonfires') 1992 *Stoneware, mixed clays, c.150 cm diam. Mino International Ceramic Competition, Tajimi, 1992. Collection of Aichi Museum, Seto*

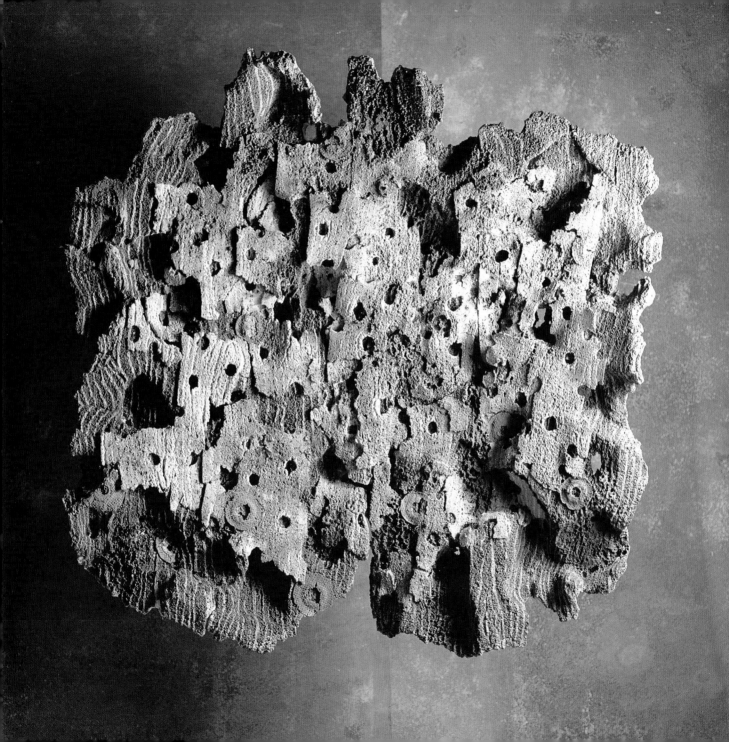

I happen, now and then, to immerse myself in sculptural questions. I never succeed. I always go back to the simple forms and to all the intricacies of fired clay.

Ab und zu vertiefe ich mich auch in bildhauerische Fragen. Nie mit viel Erfolg. Immer wieder finde ich zu den einfachen Formen zurück und zu den unzähligen Feinheiten des gebrannten Tons.

18 Cercle 1993 *Stoneware, mixed clays, 60 cm diam. Exhibited Galeria Joan Gaspar, Barcelona 1993–4*

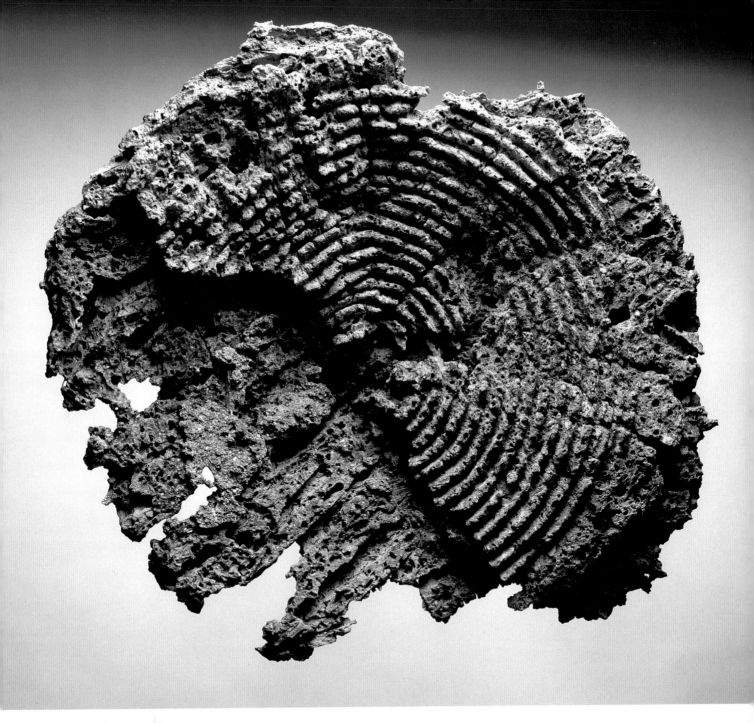

Pieces of pottery are, indeed, like photographic film which is constantly recording from the beginning to the end. Our attitudes, ingenuity, purpose and capability are recorded there. Everything is registered there, and everything is to be read there.

Keramische Stücke sind tatsächlich wie fotografischer Film, der ständig Aufnahmen macht, von Anfang bis Ende. Unsere Auffassungen, unser Erfindergeist, unsere Absicht, unser Potential sind darauf festgehalten. Alles ist dort registriert, und alles kann dort abgelesen werden.

19 Wall plate 1994 *Stoneware, mixed clays with maize, c.120 cm diam. Collection of Olot Town Hall*

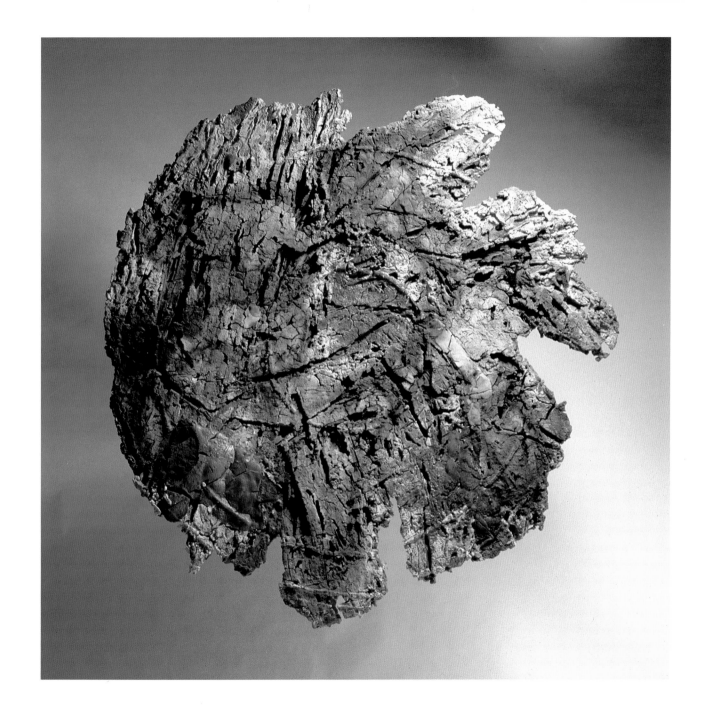

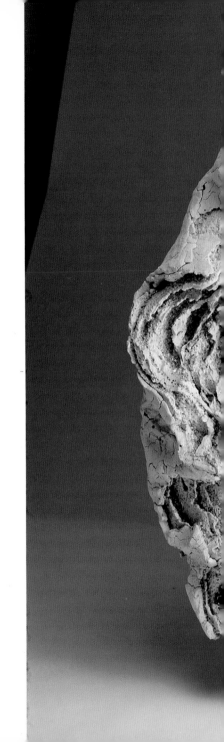

20 Large wall plate 1989 *Stoneware, mixed clays with iron, c.150 cm diam.*

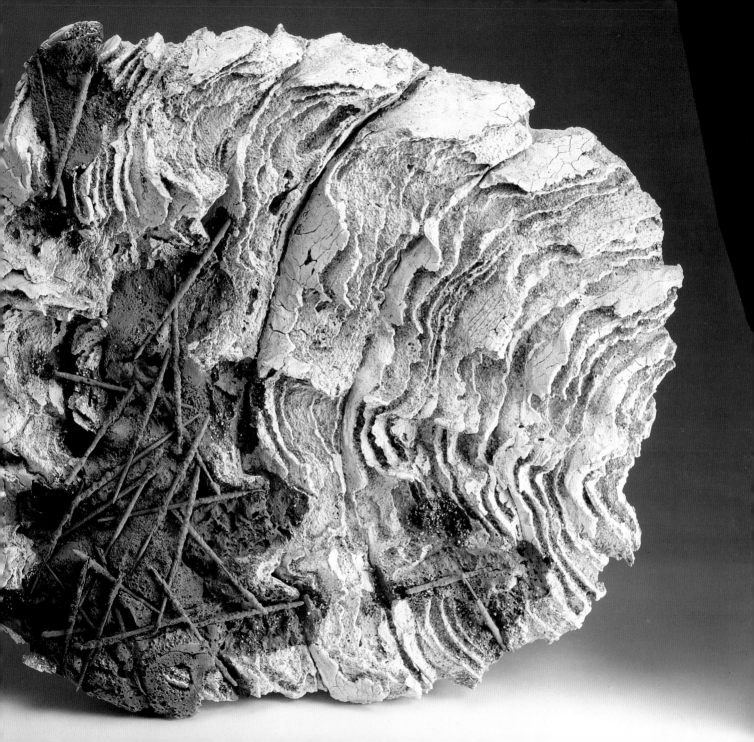

21 Centanys ('Centenarian') 1996
 Stoneware, mixed clays, 116 cm diam, 78 cm high.
 Exhibited Hetjens Museum, Düsseldorf 1996, and tour

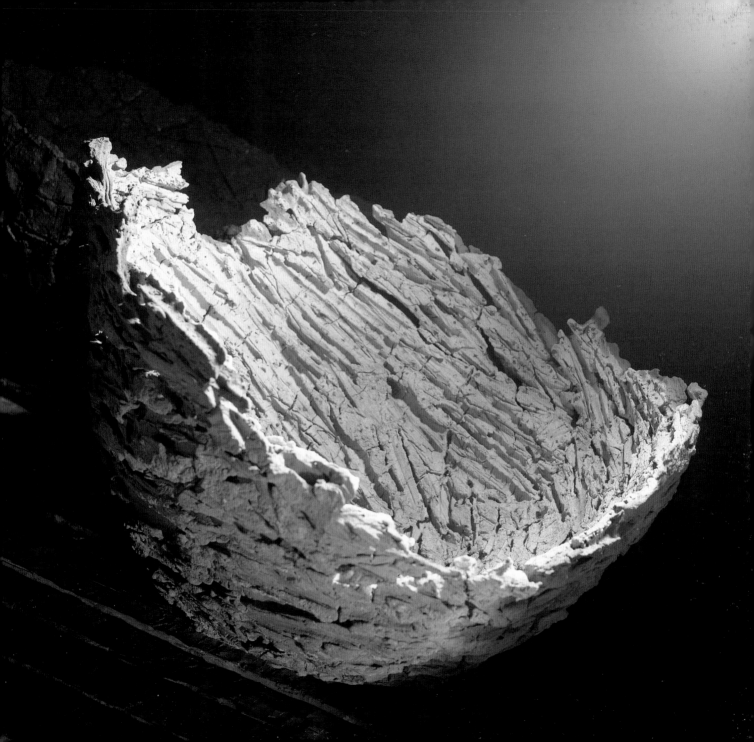

The discovery of fire is gradual. Like water, there is no one universal type of fire; sorting out its different personalities and approaching them is a slow task. Fire is unpredictable, a border you cannot step over, yet it has the same appeal as the horizon. By firing batches and breaking many a piece you learn to respect it, making an offering with every new batch, and asking its favour. Fire is always an uncertain ally, never a servant.

Clay stops being just a vehicle for water and becomes a register of fire; this is what ceramics is all about. I was and still am attracted by fire, with the smell of firewood burning, with the smoke coming out of the furnace, with the buzzing of turbines and flames going up through the chimney. And the fire, expanding, taking possession of everything, now just light and vibration, creating a country, a dominion, even a different time.

It is also a quiet moment of enduring change. Maybe the sensation of silence and peace which emanates from ceramics are rooted in this phenomenon.

Die Entdeckung des Feuers ist eine schrittweise. Wie beim Wasser gibt es kein Feuer schlechthin; seine verschiedenen Gesichter herauszufinden und ihnen näherzukommen, ist eine langwierige Aufgabe. Feuer ist unberechenbar, eine Grenze, die sich nicht überschreiten läßt, und es hat die gleiche Anziehungskraft wie der Horizont. Wenn man Stücke chargenweise brennt und viele dabei zerspringen, lernt man es zu respektieren, man lernt, aus jedem neuen Schwung Brenngut eine Opfergabe zu machen und das Feuer um seine Gunst zu bitten. Feuer ist immer ein ungewisser Verbündeter, niemals ein Diener.

Ton hört auf, bloß ein Gefäß für Wasser zu sein, und wird stattdessen zum Dokument des Feuers; darum dreht es sich in der Keramik. Ich fühlte mich hingezogen zum Feuer und bin es heute noch, wegen des Dufts von brennendem Holz, wegen des Rauchs, der aus der Brennkammer schlägt, wegen des Summens der Turbinen und der Flammen, die durch den Abzugsschlot steigen. Und wegen des Feuers, das sich ausdehnt, das von allem Besitz ergreift, das, eben noch lediglich Licht und Schwingung, sich ein eigenes Reich erobert, sogar eine andere Zeit.

Es gibt da auch einen stillen Augenblick dauerhafter Verwandlung. Mag sein, daß das Gefühl von Ruhe und Frieden, das von Keramik ausgeht, verwurzelt liegt in eben diesem Phänomen.

Claudi Casanovas

Biographical details

1956 Born in Barcelona
1959 Family moves to Olot
1990 Lives and works in Riudaura (near Olot)

Selected Exhibitions

*One-man exhibitions

1976 Girona, Fontana d'Or. Mostra Provincial d'Art

1977 Olot, Cooperativa Coure

1981 Vic, Barcelona, Sala La Tralla. *Carillo/Casanovas**

1982 Olot, Museu Comarcal. Primera Mostra Plastica Actual
 Olot, Museu Comarcal. *Escorces de Terra**

1983 Barcelona, Museu de la Ceramica. *Escorces de Terra**
 Barcelona, Dau al Set. *Ceramica Moderna a Catalunya*

1984 Madrid, Sala Adama. *Carillo/Casanovas**
 Olot, Sala Clarà. *Despres del soroll**
 Girona, Galeria Tau. *Carillo/Casanovas**
 Sant Cugat del Valles, Barcelona, Galeria Quorum.
 *Carillo/Casanovas**

1985 Figureres, Sala Art. *Despres del soroll**
 Olot, Sala Clarà. *Despres del soroll**
 Faenza, 43. Concorso Internazionale Ceramica d'Arte
 Martorell, Sala el Setze*
 Girona, Galeria Caramany. *Amfores**
 Madrid, Sala Adama. *Amforas**

1986 Vallauris. Biennale Internationale de Céramique
 Girona. Museu d'Art Modern
 Zaragoza. Cerámica y Ceramistas. *10 Ceramistas*
 Españoles
 Zaragoza. Sala Ambigú. *Exposición inaugural**
 Olot. Museu Comarcal – Cooperativa Coure

38 Ceramistes dels Països Catalans
Tokyo-Osaka. Matsuya. *European Crafts Today*
London. Fischer Fine Art. *Nine Potters*
Paris. Porte de Versailles. *Ob-Art*
Madrid. M.E.A.C. *Panorama de la Cerámica Española*
Contemporánea
Valencia. Museo Gonzales Marti. *Ceramistas para la*
Academia

1987 Palafrugell. *Artistes de Girona*
 Madrid. Galería Paul Klee. *Encuentro de la Cerámica*
 actual
 Vitoria. Galería Céramo. *Encuentro de la Cerámica*
 actual
 Carouge. Concours International
 Girona. La Caixa. *Des del fang*
 Barcelona. Centre d'Artesania de la Generalitat
 A.C.C.

1988 Düsseldorf. Hetjens Museum*
 London. Galerie Besson*
 Girona. Galeria Caramany*
 Zaragoza. Galeria Ambigú. *Vanguardias cerámicas*
 Bassano. Museo di Bassano. *Terre di Spagna*
 Logroño. Galeria Berruel. *Panorama de la Cerámica*
 Española
 Talavera. 1er. Congreso Internacional de Ceramistas
 Manises. Museo Cerámica. Primeros Premios del
 Concurso Nacional. 1972-88
 Seoul. Ministerio de Asuntos Exteriores de España
 Festival de Arte de los Juegos Olimpicos de Seoul

1989 Olot. Sala Vayreda*
 Vitoria. Galería Céramo*
 Auxerre. Abbaye Saint Germain. Touring exhibition
 L'Europe des Céramistes
 London Galerie Besson. *Summer Exhibition*
 Lugo. Sargadelos. Seminario de Verano
 London. Galerie Besson*
 Mino. II International Ceramics Competition 89

1990 Stockholm. Galleri Lejonet*
 Bremen. Bremer Landesmuseum. *Hundert Beispiele*
 Zeitgenössischer Keramik
 Girona. Galeria Caramany. *11è Saló d'Estiu*
 Girona. Galeria Caramany. *Fragments**

1991 Tokyo. Gallery Koyanagi*
Girona. Museu d'Art Modern. *Últimes adquisicions*
Stuttgart. *Europäisches Kunsthandwerk*
Shigaraki. Shigaraki Ceramic Cultural Park
Metamorphosis of Contemporary Ceramics
London. Galerie Besson*
England. Roche Court Sculpture Garden
Girona. Galeria Caramany. *Saló d'Estiu*
Tokyo. Gallery TOM. *Teabowls*

1992 Rotterdam. Museum Boymans-van Beuningen*
Castelló. Diputació de Castelló, *Monumental Ceramics*
Tokyo. Gallery Koyanagi. *Claudi Casanovas/Ryoji Koie*
Mino. III International Ceramics Competition 92

1993 Girona. Galeria Caramany. *Claudi Casanovas/Ryoji Koie*
Lappeenranta, Finland. *Keramiikka 93*
Höhr-Grenzhausen. Keramikmuseum Westerwald *Europäische Keramik*
London. Galerie Besson*
Manises. Casa de Cultura, Museu de la Ceràmica*
Girona. Sales Municipals d'Exposicio*

1994 Olot. Sala Sant Lluc. *Cercles*
Barcelona. Galeria Joan Gaspar*
New York. Garth Clark Gallery*

1995 Girona. Museu d'Art. *De la terra i del Foc*
Châteauroux 8th Biennale
Bandol. Le printemps des potiers. *Potiers Catalans*

1996 Dieulefit. Maison de la Terre. *Terre Catalane*
Saarbrücken. Saarländisches Künstlerhaus. *Das andere Gefäss*
Barcelona. Museu d'Argentona*
Castellomonte. Museo della Ceramica, *Ceramica Spagnola*
Palafrugell. Galeria Lluis Heras*
Düsseldorf. Hetjens Museum. *Pedra Foguera*
London. Galerie Besson. *Teabowls*

1997 Middelfart. Keramik Museet Gimmerhus. *Pedra Foguera*
Dunkerque. Musée d'Art Contemporain. *Pedra Foguera*

Awards

1978 Concurso Nacional de Cerámica. Manises. 1st Prize

1981 Concurs Margarita Marsà. Galeria Tramontan Palamós. 1st Prize
Concurso Nacional. Talavera de la Reina. 3rd Prize
Concurso Nacional de Cerámicá. Manises. 3rd Prize
Beca d'Arts Plàstiques Ciutat d'Olot. Olot

1985 Convocatòria d'Art. Sala Clarà. Olot. 1st Prize
43. Concorso Internazionale Ceramica d'Arte Faenza Emilia Romagna Award
Castello, Sala Alcora 1st Prize

1986 Biennale Internationale de la Céramique. Vallauris Grand Prix
Beca d'Arts Plàstiques de la Generalitat de Catalunya
Concurs Nacional. 1st Prize

1989 II International Ceramics Competition 89. Mino. Japan Honourable Mention

1990 Beca d'Estudis. Departament de Cultura. Generalitat de Catalunya

1992 III International Ceramics Competition 92. Mino. Japan Grand Prix

Work in Public Collections

Alcobaça, Portugal ARCO.
Alcora, Colecció Concurso Nacional.
Barcelona, Museu de la Cerámica.
Düsseldorf, Hetjens Museum.
Faenza, Museo della Ceramica.
Girona, Museu d'Art Modern, Colleccio Diputació.
Girona. Diputació de Girona. Claustres.
Manises, Museu de la Ceràmica.
Mino, Public Collection International Ceramics Competition
Norwich. Sainsbury Centre for Visual Arts.
Olot, Museu Comarcal de la Garrotxa.
Rotterdam. Museum Boymans-van Beuningen.
Sargadelos, Museo de la Factoría.
Seto, Aichi Ceramic Museum.
Shigaraki, Ceramic Cultural Park Museum.
Stockholm, Nationalmuseum.
Talavera de la Reina, Colección Concurso Nacional.
Vallauris, Musée de la Céramique.